D0515951

# THE ART OF DISCOVERY

*Exploring a Northwest Art Collection*

JUNIOR LEAGUE
*of* SEATTLE

*Thank you to* **LAIRD NORTON TYEE** *for its generous sponsorship of this book.*

*The Art of Discovery,* Exploring a Northwest Art Collection

The artwork featured in this book is the property of the Junior League of Seattle, Inc., and is part of the Northwest Art Project community program's larger collection of art used by the Junior League of Seattle and its volunteers for educational purposes within the greater Seattle area.

Profits from the sale of this educational book are used to support the Junior League of Seattle's Northwest Art Project.

Library of Congress Control Number: 2010927566
ISBN: 978-09636088-0-2
Manufactured in Shenzhen, Guangdong, China by C & C Offset Printing Co., Ltd. in October, 2010.

**The Junior League of Seattle**

| | |
|---|---|
| Project Chair and Design Editor | Bonnie Marshall |
| Project Sustainer Chair | Tricia Tiano |
| Lead Editor, Contributing Writer | Kate Jack |
| Editor, Contributing Writer | Mary Chapman |
| Artist Liaison | Cynthia Kelly |
| Copy Editors | Maggie Adams |
| | Rachel Strawn |

**Credits**

| | |
|---|---|
| Art and Education Writer | Halinka Wodzicki |
| Book Design and Layout | Kate Basart |
| Production Manager | Elizabeth Cromwell |
| Color Management | iocolor, Seattle |
| Cover Art | Catherine Eaton Skinner, *Dog Days of Summer II* |

**Special Thank You**

Thank you to the artists, artist families, and artist estates for your time and help in making this project a success and for allowing the Junior League of Seattle to reproduce the artwork represented in this book. Thank you for your continued support of our Northwest Art Project community program.

**The Art of Discovery**

To order additional copies of *The Art of Discovery,* or for more information about the Junior League of Seattle and its Northwest Art Project community program, please contact:

The Junior League of Seattle / 4119 East Madison Street / Seattle, WA 98112 / 206-324-3638 / www.jrleagueseattle.org

# CONTENTS

# INTRODUCTION

Welcome to *The Art of Discovery,* which celebrates the Northwest Art Project, the longest running community program of the Junior League of Seattle (JLS). Since the program began in 1960, it has traveled to public and independent schools in the Puget Sound region, where it has been introduced to more than 250,000 students. Trained docents help the children understand and appreciate these original works of art during the several weeks they are exhibited at each school.

The Northwest Art Project was the creation of Dee Dickinson, an innovative educator, civic leader, and JLS member. She, and others in the JLS, felt that it was important for local school children and the community to become familiar with and be inspired by the unusually rich artistic environment here in the Northwest. What better way to teach children and volunteer docents about Northwest art than to provide firsthand experiences with original works?

In 1960, the first paintings, prints, and drawings were selected by a jury of art professionals and purchased by the JLS. The selected works were by well-known Northwest masters. As the project continued, new artworks were purchased to provide further examples of important Northwest art.

Today, the JLS Northwest Art Project consists of more than 75 pieces of original art, containing a mixture of paintings, sculptures, prints, photographs, mixed media pieces, and glass art. Included in the JLS's Collection are artworks by recognized Northwest artists such as Guy Anderson, Kenneth Callahan, Dale Chihuly, William Cumming, Marita Dingus, Morris Graves, Helmi Juvonen, Paul Horiuchi, Fay Jones, Jacob Lawrence, Spike Mafford, Alden Mason, Sherry Markovitz, Penny Mulligan, Catherine Eaton Skinner, Norie Sato, Mark Tobey, George Tsutakawa, James Washington Jr., and many others.

Our docents use a multi-sensory approach to share the art with children in small class settings. Students are invited to imagine not only what a piece of art looks like, but also how it might feel, smell, taste, or sound. They are also encouraged to create their own works of art inspired by what they see. This develops curiosity, higher-order thinking skills, and the ability to see projects through from beginning to end—all skills in high demand in the world today.

This book was designed to share the artworks and art appreciation techniques from the Northwest Art Project with our entire community. We hope you enjoy *The Art of Discovery!*

# HOW TO USE THIS BOOK

What can you learn from a work of art? In what ways do artists tell a story? If you were the artist, how would you show your emotions, or reveal your dreams through imagery? Answer these questions and more as you embark on a journey through *The Art of Discovery*.

## DISCOVER PEOPLE, PLACES, AND ANIMALS

The twelve artworks featured here come from the Junior League of Seattle's Northwest Art Collection, and have been divided into three sections: **PEOPLE**, **PLACES**, and **ANIMALS**. Each artwork is accompanied by questions and text that will spark a dialogue about how artists communicate through visual art. Art terms are defined to expand vocabulary specific to visual art.

## MAKING ART AFTER LOOKING AT ART

Each artwork is followed by a related art lesson that acts as a springboard for a journey of self-expression for adults and children. Before you embark on an art project, take time to mix paints and experiment with drawing tools and techniques. A list of suggested materials and time allowance for each lesson is provided. Brief biographical information gives readers a glimpse at each artist's past and inspirations.

## EXPLORE MORE

Use an artwork as a point of inspiration to write a poem or short story, or to put on a skit. Listen to music that has a similar theme. Explore connections to science and other cultures. Each artwork features some suggested ways to take your exploration one step further.

## SOME THINGS TO CONSIDER

*Looking at Art Takes Time*

We are bombarded by visual images every day. The descriptive text and open-ended questions are designed to slow down the looking process so that the impact and meaning of each artwork can be uncovered.

Don't rush the process of *discovery*. You may only have time to look at one or two artworks in a sitting. Choose artworks you like, then spend time exploring them. Revisit the artworks. Art can be complex.

*A Work of Art is Like a Puzzle*

Help unlock the meaning of a work of art by asking exploratory questions of yourself or
others, like:

"What do you see?"

"What do you notice in the artwork that makes you believe that?"

Other questions to consider:

"What does it make you think about?"

"How do you feel when you look at this artwork?"

"What do you think it meant to the artist who made it?"

*Everyone Sees Art Differently*

Have fun learning how to look at art and to talk about art. Be inspired to find your own
path through *The Art of Discovery*.

 **ABOUT THE ART AND EDUCATION WRITER**

**HALINKA WODZICKI** has been an art museum educator for
more than 20 years. She was curator of education for the Tacoma
Art Museum, and currently works for the University of Washington's
Henry Art Gallery as a kindergarten through 12th grade art educa-
tion consultant and program manager. In 2001, she began a long-
standing connection with the Junior League of Seattle's Northwest
Art Project community program. In addition to training docents on
effective teaching strategies, she wrote the Northwest Art Project's
curriculum materials which are distributed to participating schools.
Wodzicki lives in Seattle with her husband and three children.

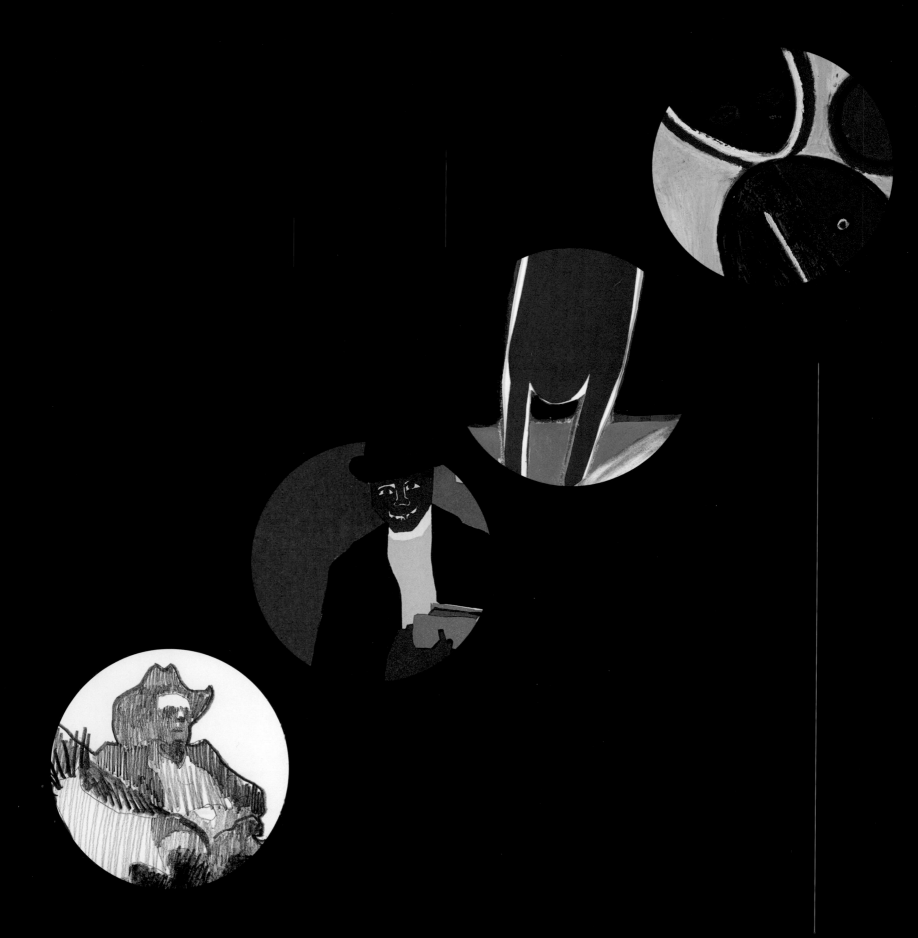

# PEOPLE IN ART

When we look at art, it is as if we can see things through someone else's eyes. What does

it feel like to ride a bucking bronco? Or walk down a busy city street? Take a look at the

people pictured in this section. What would you say if you could talk to them? Which person

would you most like to be?

# DISCOVER PEOPLE IN MOTION

William Cumming, *Rodeo Rider*, 1981
graphite on paper, 28¾ x 23½ inches

Chaps flying, back arched, this cowboy is hanging on for dear life. Will he tame the horse, or will the horse throw him off?

With only a simple drawing pencil, William Cumming manages to freeze that split second when a bucking horse's hooves are high off the ground. What happens next? Will the horse's back start to straighten and drop back towards the ground, or will the bronco continue to lift the rider higher?

Examine the bold contour line that gives life to the horse and rider. Start at the tip of the front hoof and follow the dark, fluid line around the horse's tail. Trace this continuous line as it defines the rider's chaps and his hat, then pulls you down the horse's mane and around its muzzle. Find the place where Cumming lifted his pencil off the paper and made this line almost disappear. Notice how the heavy line unifies the horse and rider, making the pair seem inseparable. Without skipping a beat, the artist drew this outline first, and then with pencil strokes of varying thickness and darkness he gave the horse bulk, and the rider form.

Now let's look at the other types of lines that define the horse. Compare the lines on the tail to those on the horse's legs and torso. Why would the artist draw lines farther apart on the tail and closer together on the horse's body?

All parts of this drawing are important. Cover up the small patch of shadow under the horse with your hand. By pretending that it is not there, you can see how it helps us imagine that this horse is leaping into the air.

"I was always drawing the figure in motion," Cumming once said. He is interested more in people who are moving rather than people who are sitting still. Cumming believes that "gesture explains the man." In other words, he feels that the way we move our bodies tells a lot about what we are thinking and feeling. What does the rider's body display? Confidence, concentration, or fear? Is he in control or will he be bucked off?

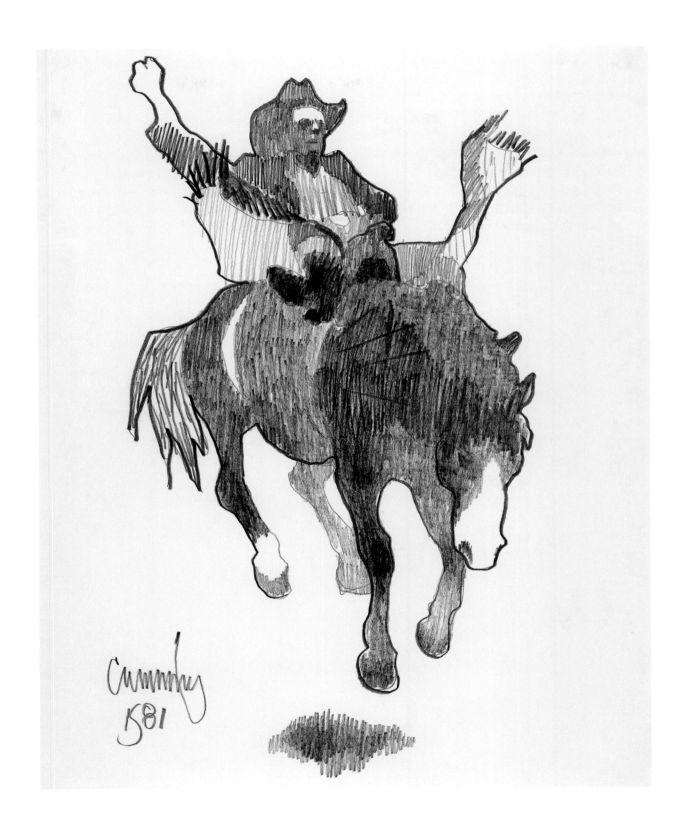

# MAKING ART AFTER LOOKING AT ART: *People on the Move*

### DRAW A PERSON PLAYING A SPORT, DANCING, OR SIMPLY WALKING

When Cumming was 12 years old, he read a quote by the 19th-century French painter Eugene Delacroix: "If you can't draw a man falling from a fifth-story window before he hits the pavement, you'll never be an artist." Challenged and inspired, Cumming filled sketchbooks, drawings, and paintings with people and animals in motion. Whether his subjects were walking, skipping, dancing, or riding horses, he said, "Movement, the human body in movement, fascinates me." Now it's your turn. Make a series of drawings that capture a person in motion.

ESTIMATED TIME: 2–5 MINUTES PER DRAWING

 **MATERIALS**

- Paper
- Pencils or markers
- Clipboard
- Clock

 **STEP BY STEP**

*Stop-Action Figures in Motion Drawings*
- With a pencil or marker and a piece of paper secured to a clipboard, quickly sketch a friend who is jumping, dancing, or playing.
- Start at the top of your paper and draw strong lines, using big, fluid arm movements to catch your figure in motion. Quick! Draw fast and skip the details. Draw your friend before they hit the ground!

*Blind Contour Drawings*
Can you draw a person frozen in motion without ever looking down at your paper? Read these instructions carefully, then give it a try.
- Ask someone to be your live model. Have your model pretend that they are dancing or playing a sport (tennis, soccer, or swimming, to name a few). Notice how your model is moving and then ask him or her to hold a pose for two minutes.

- Look closely. Then draw one continuous contour outline or silhouette of your model. Start with your pencil near the top of your piece of paper and don't lift it until your two minutes are up. Your line may wander across the form and back out again, capturing details along the way. Work fast, and try to get the entire figure before your model moves. Don't peek!
- Surprise! Look down to see how you captured your figure in action.
- Try it again. Ask your model to assume a different pose and draw her or him once more without looking down at your page. Practice makes perfect. This is one activity that you get better at each time you try.
- Now switch places: you pose for your friend.
- Another thing you can do is go back into one of your contour drawings and add light or dark interior lines that define the form and create different values of color. Like Cumming did with *Rodeo Rider,* experiment by making lines of varying darkness.

*Kassidy, Age 6*    *Matthew, Age 6*    *Katie, Age 6*

 **EXPLORE MORE**

*Strike a Pose*

What is your favorite physical activity? What do you like best about it? What is the most challenging part for you? Act it out in slow motion. Hold still in your favorite pose and ask a friend to write down a list of words that describe how you look and feel. Write about your experience.

*Think About It*

What new physical activity would you like to try? Why?

*Learning Focus*

Drama, Language Arts

**MORE ABOUT THE ARTIST**

When he was a teenager, **WILLIAM CUMMING** (1917– ) mowed a neighbor's lawn in Tukwila, Washington, in exchange for a ride to Seattle each week so that he could study art history books at the Seattle Public Library. He later went on to become closely associated with the "Northwest School" of artists, which included Morris Graves, Mark Tobey, Guy Anderson, and Kenneth Callahan.

# DISCOVER PEOPLE IN A COMMUNITY

Jacob Lawrence, *Windows*, 1977
lithograph, 26¼ x 29½ inches

City streets are busy places. Lots of people are coming and going. Who might you bump into on this sidewalk? A preacher? A schoolboy?

This is a small space for so many people. Try drawing a line with your finger that shows which direction each person is going. So many lines crisscross, no wonder we might collide with someone.

Find the carpenter who seems to be in a hurry. Jacob Lawrence often included builders in his artwork. He admired them for their physical strength, and he saw them as symbols for how a community works together to make itself stronger. Look at the carpenter's muscular shoulders and large hands. They are the marks of a hard worker.

What do the windows add to this artwork? If you cover them up with your hand, you can see how important they are. They add to the bustling street scene, and they also help us think about all the different things that happen on any given day in a community.

Lawrence once said, "I grew up in NYC (New York City). I guess when you grow up in any city you become familiar with doorways and windows and looking through windows. . . ." Here, Lawrence invites us to look in; we don't even have to be sneaky about it. What is going on in each window?

Lawrence is a master at keeping your eyes busy and not letting them rest too long in one spot. In this picture, he carefully places colors so that your eye travels all the way around the composition. To see how this technique he used works, use your hand to show how the areas of white dance across the page. Do you see how the ring on the man's finger catches your eye? Find other places where patches of white grab your attention.

Trace a line connecting all the areas of red to each other. What type of line did you make? This careful placement of colors creates unity and encourages you to examine the whole artwork. Try this trick the next time you make art; it is a sure way to keep your viewer's eyes moving around your artwork.

The **ELEMENTS OF ART** are color, line, shape, space, form, texture, and value.

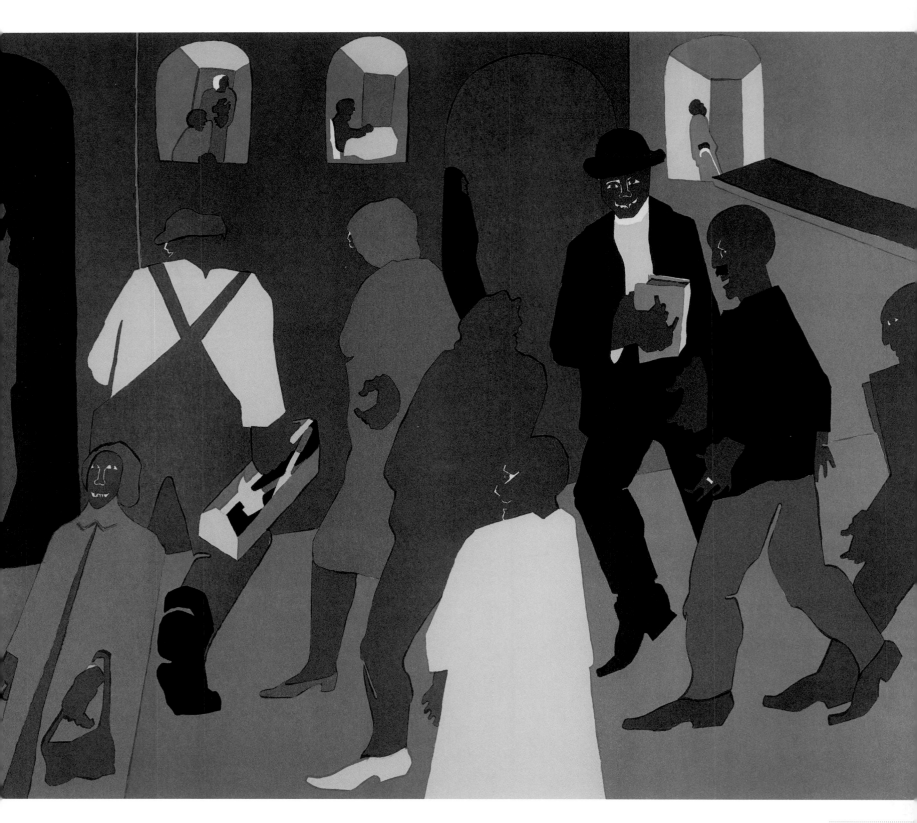

# MAKING ART AFTER LOOKING AT ART: *People in Your Neighborhood*

## MAKE A CUT-PAPER COLLAGE OF THE PEOPLE YOU SEE IN YOUR COMMUNITY

As a student in the Harlem Art Workshop, Lawrence was encouraged to look around his neighborhood for ideas. He saw apartments, fire escapes, shop windows, children playing, and people running errands or working hard, then turned these into art. Even after he moved to Seattle to teach at the University of Washington, he continued to include scenes from Harlem in his art. Now it is your turn to make a scene from your neighborhood.

ESTIMATED TIME: 1 HOUR

 **MATERIALS**

- Colored fadeless kraft paper
- Scissors
- Glue

 **STEP BY STEP**

*Planning*

- Think about your neighborhood. Make a list of the people, young and old, who live there. What are a few of the different jobs that people have?
- Is there a place where all types of people get together in your community? Brainstorm a list of examples.
- Think about what Lawrence once said about a window: "It's always used as a backdrop, a prop, for my imagery. I imagine that much of our symbolism comes from our experience. Had I been born in the country, maybe I would use different kinds of form." What sort of backdrop would you use? (Ideas: a row of shops in a mall, a building, or trees in a park.)

 **COLLAGE**

*Making a Setting*

- "When the subject is strong, simplicity is the only way to treat it," Lawrence once said. Look back at *Windows* to see how he made a very simple setting. Do you see how he used a few lines and shapes to make a street and the side of a building?
- Choose a colored sheet of kraft paper for your base. Choose another color that is in contrast to the base for the backdrop. Cut out one large shape to help you define the backdrop. Try to use only a few lines and shapes. Glue the backdrop on top of your base.

## Learning from Lawrence

Lawrence used only a few colors and repeated them throughout his composition. As he painted, he would work with just one color at a time. This technique helped him to distribute colors evenly, and to create balance so that neither side looked heavier than the other. He also made sure to place contrasting colors next to each other to make his artwork pop.

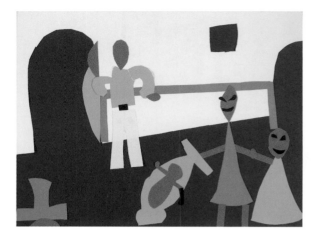

*Maddy, Age 9*

## Adding People

- Choose three more colors for people or props. Add at least five different types of people to your scene. See if you can show them in action going about their day. Cut large, simple shapes. You'll add details later.
- Like Lawrence, try to work with one color at a time and move across the picture plane to distribute your colors evenly.
- Once you are finished arranging your scene, glue down all of the pieces. Step back and look at your picture again. Does your eye travel around the composition?
- Choose one additional color for accents and details (Lawrence used white).

## EXPLORE MORE

### Take Action

Lawrence's art inspired communities to come together and feel united. Can you think of a neighborhood organization that makes a difference in your community? Create an artwork that could help this organization spread their message. Make a poster to remind people to recycle, paint a mural to beautify your neighborhood, or use some chalk on the sidewalk to inspire a smile . . . use your imagination and get to work!

### Think About It

What are some other ways that you could make your community a better place? Find a place where you would like to volunteer your time.

### Learning Focus

Social Studies

### MORE ABOUT THE ARTIST

Renowned for his bold use of color and imaginative style, **JACOB LAWRENCE** (1917–2000) took art classes as a child from prominent African American artists involved in the Harlem Renaissance. He loved studying art from other cultures so much that he regularly walked over 60 blocks to the Metropolitan Museum of Art just so he could sketch from masterpieces. You can see his paintings there, as well as at the Smithsonian Institution, the Seattle Art Museum, and even the White House.

# DISCOVER PEOPLE COMPETING

Michael Spafford, *Three Divers Red*, 1978
oil on paper, 33 x 37 inches

Have you ever attempted to do something just right? Have you ever tried hard to win a race? The artist Michael Spafford respects the effort it takes for athletes, especially Olympians, to compete.

Paintings are still, but divers move fast. What are the ways that Michael Spafford is able to make the divers look like they are in action when they are not? We can almost feel them plunge.

Sometimes an artwork can be read in a few different ways. Look at this picture again. Can you see how the artist makes it seem like we are looking at one diver over time rather than a triptych of three diving at once? It is almost as if each panel is a frame in a movie. Cover up two of the panels. Can one panel stand apart by itself, or do you need all three to tell the full story?

Let's look closely at how small strokes of color can suggest a swimming pool. Point to the water line in each panel. What could the short red marks on the horizontal blue line symbolize? What about the thin red vertical lines dividing the painting into three—what could they represent? Do any other parts of the artwork help you imagine the swimming pool?

In *Three Divers Red,* we are watching a competition between athletes. After watching American swimmer Mark Spitz win seven gold medals in the 1972 Olympic Games, Spafford made a series of paintings like this one about the power of hard work and achievement. In this painting, how is he able to show a diver's determination to win?

Like athletes, artists work hard at what they do. Even though Spafford has been making art for a long time, often working late into the night, he once said, "I have never been able to get a painting right the first time." Look closely to find the place where the artist changed his mind. It may be tricky to see in this reproduction, but the diver on the right has been cut out and glued over whatever image was on the canvas before. What do you think used to be in its place? To Spafford, this change makes the painting just right. What do you think?

Next time you make a mistake after having worked hard on an artwork, take a tip from Spafford. Cut out the error and glue down something you like in its place to make the work just right for you.

A **TRIPTYCH** is a set of three panels or compartments side by side.

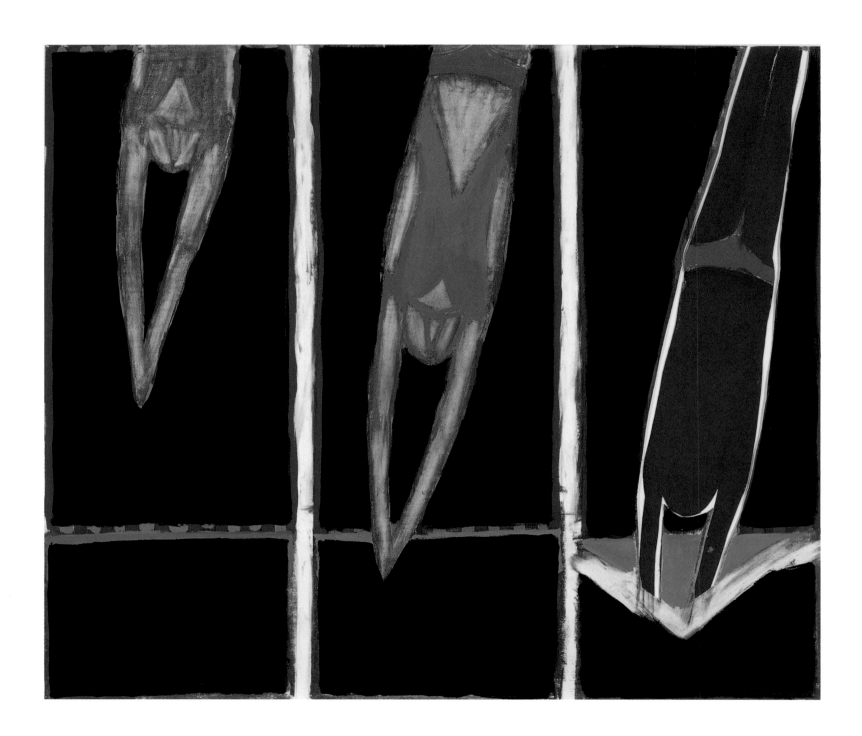

# MAKING ART AFTER LOOKING AT ART: *People Trying Their Best*

## MAKE A TRIPTYCH THAT SHOWS THREE PEOPLE COMPETING IN A RACE

Imagine how much commitment it takes to be in the Olympics. Spafford admires athletes who train hard to do their best. Pretend you are participating in an Olympic event. Make a triptych, a series of three prints, that shows you trying to win a race or event against two other athletes.

ESTIMATED TIME: 45 MINUTES

 **MATERIALS**

- Water-based printing ink
- Brayer (roller)
- Paper
- Pencil
- Three Styrofoam sheets (or rinsed foam food trays)
- Plastic tray

 **STEP BY STEP**

*Planning*

- Brainstorm a list of sports. Some examples include running, swimming, skiing, skating, rowing, and gymnastics. Choose one.
- Imagine participating in your sport in the Olympics. What would it feel like to put all of your energy into trying your best?

*Sketching*

- Pose as if you are competing and really want to win. Notice how your body is moving. Are you trying as hard as you can? Look in a mirror to see your pose.
- Think about what Spafford once said: "I try to describe a shape in a verb sense—to show a figure falling, grabbing, or reaching." He went on to say, "I think I like that kind of subject matter because it allows me to make paintings look powerful, look exciting, or look visually active."
- Ask a friend to remain still in a powerful pose. Draw his or her silhouette. Begin with an oval head and a basic shape for the body, and then add lines to show the movement of arms and legs.
- Draw the silhouettes of two more athletes competing in the same event, but use slightly different poses.

12

*Printmaking*

- Copy each of your three drawings onto three separate sheets of Styrofoam by using a pencil to press lines firmly into each sheet. Like Spafford, you can also add a few lines to define the setting. Don't write words—they'll print backwards.
- Squeeze out a bit of ink onto a flat tray and roll it back and forth with a brayer. Roll the ink onto the foam sheet. Try to get a thin, even coat of ink onto the surface. If you have too much ink, it will seep into the indentations.
- Run test samples of each of your prints. Place your foam sheet face down onto a piece of paper and rub the back of it firmly.
- Lift up the foam sheet to see your print. Did you have the right amount of ink? Do you need to press any lines down further? Make changes if necessary, then try it again.
- Now make a triptych that shows three athletes competing, each attempting fiercely to win!

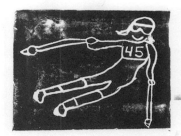
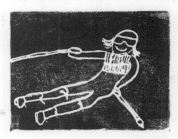

## EXPLORE MORE

*Overcoming Obstacles*

Read about one or more extraordinary athletes that you admire in a book or on the Internet. Pay close attention to the moments in their athletic careers when they were faced with obstacles. How did they overcome these challenges? Tell someone about a time when you wanted to give up, but stuck to it and accomplished your goal.

*Think About It*

What is more important: trying your best, winning, or being a "good sport?" Why?

*Maggie, Age 9*

*Learning Focus*

Character Education

## MORE ABOUT THE ARTIST

Has your mother ever encouraged you to make pictures? **MICHAEL SPAFFORD'S** (1935–  ) mom did. When he was young he wanted to be a cartoonist. And now he's an artist! He traveled the world, from Mexico City to Rome. He taught at the University of Washington for more than 30 years where he was a colleague of Jacob Lawrence and Norman Lundin. Along the way he developed a style all his own, with great big brushstrokes and lots of paint.

# DISCOVER PEOPLE WAITING

Joe Max Emminger, *Two People Waiting*, 1988
oil stick and acrylic on paper, 50 x 64 inches

Have you ever waited a long time for something to happen? How did you pass the time? The two people in this picture are waiting too. Let's figure out what they are waiting for.

Step onto the field of red. The artist Joe Max Emminger gives a few clues to help us imagine the place. Is that a twig, or the footprint of a bird? Or is the white shape something else? What could be lying next to it? Step further into the artwork and cross over the rectangular blocks. Do you see them as a part of a sidewalk, or a garden path, or something different?

Look at the two people waiting. Use your finger to outline the shapes and lines that define their faces. How many different geometric and organic shapes can you find? What do you think the green rectangle could be? Can you find any lines that look like letters in the alphabet? Who knew a nose could look like a backwards J! Many parts of the face are missing. Can you name them? Why do you suppose the artist decided to leave them out?

Emminger said, "It looks like the two people's heads are bouncing off of one another." Why do you think their heads are touching? Do they look bored or tired? What are they doing? They could be thinking about the same thing. Or maybe they are just trying to pass the time while they wait.

This artist loves using the primary colors of yellow, red, and blue. "I want my art to jump off the wall," he has said. How would the mood of this artwork change if he had used grays and browns instead?

"My favorite color is blue. It is the color of infinity," Emminger once said. Point to a place where blue seems to go on forever. Can you find a shape that reminds you of the moon? Perhaps the two people have been waiting so long that day turned to night.

Let's talk about the bird and see where it fits in. How would you describe it? Emminger's love of telling stories in pictures has led him to leave a bit of himself in each artwork. "I am always the bird, the observer in my paintings—that's me!" When he's finished with it, the bird stays on to watch over his artwork.

Were you able to figure out what these people are waiting for? Next time you are waiting for something to happen, try making some art. It is a great way to pass the time.

**GEOMETRIC SHAPES** can be measured like a square, circle, or triangle.

**ORGANIC SHAPES** are free-form shapes that may be found in nature. They cannot be measured.

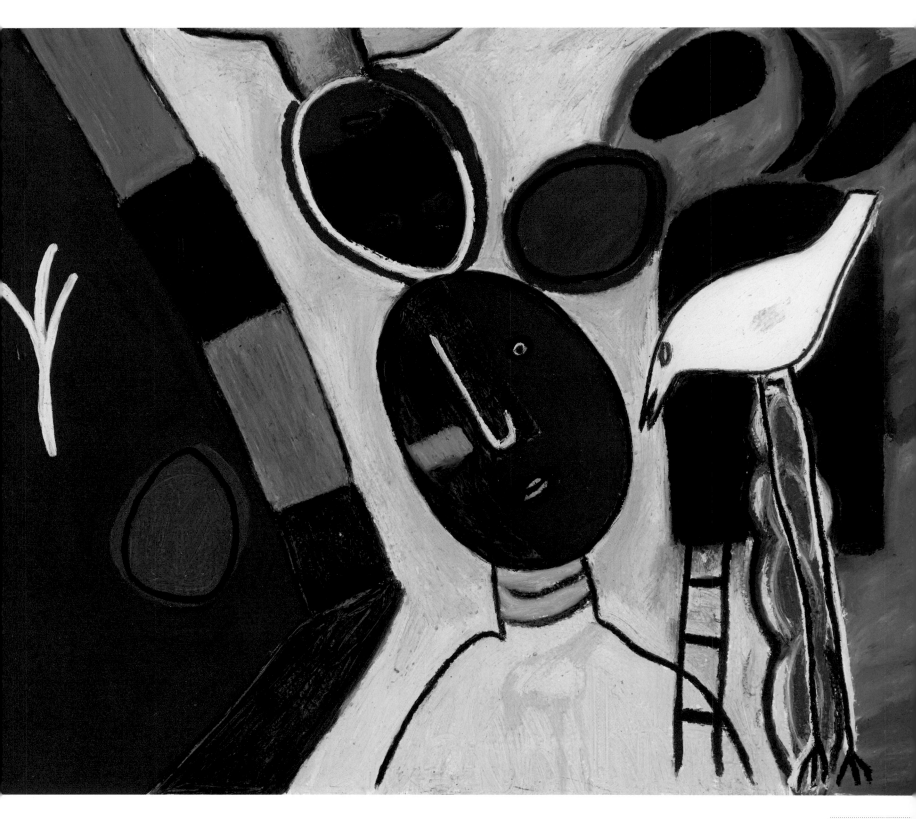

# MAKING ART AFTER LOOKING AT ART: *Two People . . .*

## MAKE A DRAWING OR PAINTING THAT DEPICTS TWO PEOPLE DOING SOMETHING

Emminger tells stories about his life and experiences through his art. He uses simple shapes, clear outlines, and bold colors to create a joyful celebration of life. He once said, "What I do and what kids do, there is no difference, though kids do it better than me. Their air is fresh. I'm trying to get back to that place." Celebrate life's simple pleasures like Emminger and make a picture about two people doing something together.

ESTIMATED TIME: 1 HOUR

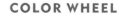

**COLOR WHEEL**

 **MATERIALS**
- Large sheets of sturdy paper
- Light colored chalk
- Tempera paint
- Brushes

 **STEP BY STEP**

*Planning*

Think about an activity that shows two people doing something. Brainstorm some ideas (standing, looking, reading, playing, jumping, etc.). What objects do you need to include in your artwork to express what the people are doing?

Emminger often puts a bird in his pictures to look after them once he is finished. Have you ever imagined that you were an animal? What animal would you leave behind in your artwork? Why?

*Sketching*
- Using chalk, lightly draw two lines (straight, angled, or curved) that divide your paper into three sections. The lines should be very faint and will serve only as a guideline when you paint.
- In one section, lightly sketch the outlines of two figures with the following:
  - oval head
  - a simple body
- Look at the list of objects from your brainstorming. Choose at least one to include in your painting. Use simple shapes and/or lines.
- Find a place for your animal and sketch it in with chalk.

**PRIMARY COLORS** are special because when you mix combinations of them together you are able to get any other color. No other colors can be used to create a primary color.

**SECONDARY COLORS** are colors that are created by mixing two primary colors.

16

*Chloe, Age 5*

## Painting

- Use tempera paint to apply color. First, fill in the three large sections using the primary colors of red, yellow, and blue.
- Next, follow the sketch lines and color in the people, objects, and your animal. Use a secondary color (green, purple, or orange), or white for accents. Once the paint is dry, add details such as lines or geometric shapes for the nose, eyes, and mouth. For fun, hide some lines that look like letters!
- If you paint something you hadn't planned on using in your artwork, think about what Emminger once said: "I love mistakes. They take me to a place where I didn't know I could go." How can you make your mistake into a part of your art that you love?
- Once the paint is dry to the touch, go back in with a thin brush using black to outline objects and people.
- Choose a title for your artwork by completing this statement:

*Two People* _____.

### EXPLORE MORE

*Waiting Games*

Waiting is something we often find ourselves doing. Waiting for the seasons to change, waiting for a birthday, or simply waiting for a bus. What are some things that you can do to fill the time? Make a list. Challenge yourself to avoid using electronic devices. Now invent your own "portable" game to play while you wait.

*Think About It*

What would happen if we never had to wait? Would that make things better or worse? Why?

*Learning Focus*

Character Education

### MORE ABOUT THE ARTIST

**JOE MAX EMMINGER** (1944– ) grew up in Seattle, where he enjoyed sports, music, and dancing. His father painted houses, and Emminger has fond memories of the bright colors his mother chose for the inside of his childhood home. He taught himself how to paint with the famous works of Matisse and Chagall as his guide.

# PLACES IN ART

Artists get ideas from the world around them. In the Pacific Northwest, it is mostly sunny

and warm in the summer, then cloudy and rainy from fall to spring. As you look at each

artwork in this section, try to imagine how it feels to be in that place. Do you like it there?

Which one of these artworks would you want in your own home? Where would you put it?

# DISCOVER PLACES INSIDE

Norman Lundin, *Yellow Towel in Studio*, 1981
pastels, charcoal, and dry pigment, 52 x 40 inches

Can you remember all the details and objects in a room? Some artists draw what they see, while others draw what they imagine. The artist Norman Lundin says, "I never paint from direct observation but always from my imagination."

This drawing is so realistic that at first you may think it's a photograph. Pull the picture up close and find some places where the details look quite real. Can you identify the reflections on the wooden floor? The chalk dust on the eraser? Where does your eye go first? Perhaps the large towel because it's the brightest splash of color.

Now step into the studio. Watch out. Don't trip on the cords! That's odd—why would someone leave them there? A large window is letting in a flood of sunlight. Can you figure out the shape of the window by looking at the shadows? The edge of a doorway is on the left. Where does it lead?

Let's look at those extension cords again and think about why Lundin put them there. The cords add variety because they are one of the few curved lines in the picture. Also, like the imagined window and edge of the doorway, they pull us out of the picture to an unknown place.

Now look at this picture in a different way, the way Lundin looks at art. This time look at the shapes that the objects make. With your finger, outline all the geometric shapes that you can find. Did you find small shapes inside larger ones? Point to places where he stacked the same shapes on top of each other.

Filling an empty canvas is like a game for Lundin. He once said that places don't look the way he wants them to, "so I change things." As he works he adds objects and takes them away until the artwork looks just right. Then he adds something a "little strange"—like an extension cord lying where someone might trip on it, just to make us look more closely.

Next time you make art, play Lundin's game. Create a place that looks authentic and is arranged according to the shapes that objects make. Then add things that make us wonder what we can't see, but can imagine.

**NEGATIVE SPACE**
is the empty space around
an object or form.

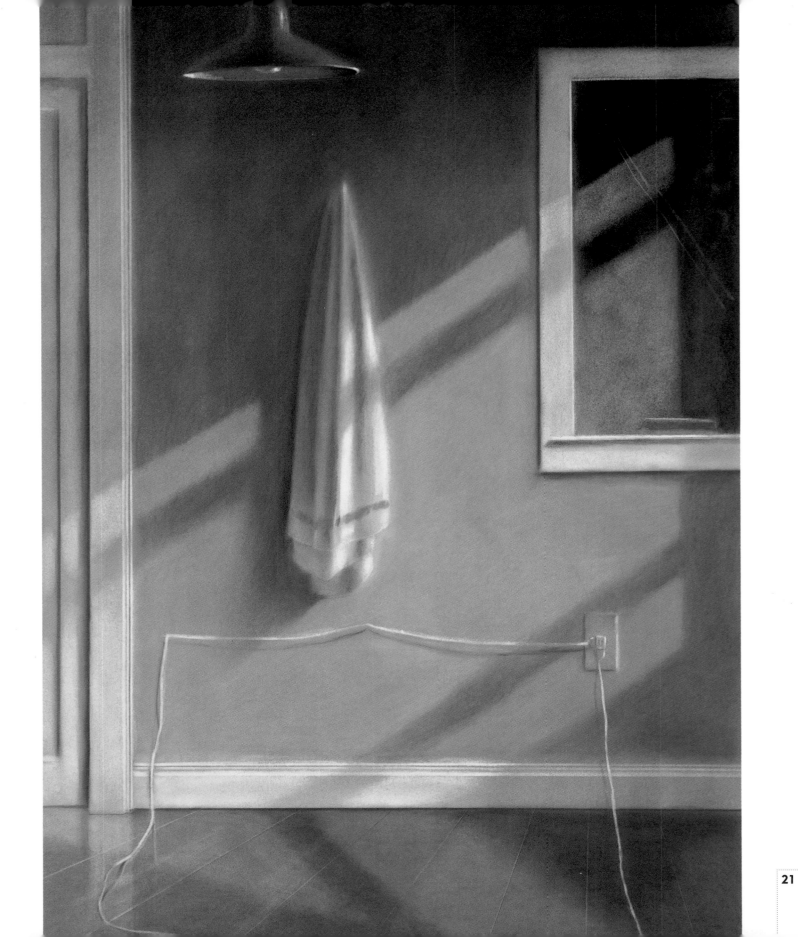

# MAKING ART AFTER LOOKING AT ART: *Made-Up Places*

## DRAW AN ARRANGEMENT OF ORDINARY OBJECTS IN A ROOM

Lundin makes art about places that don't exist, but look like they could. Arranging objects in a space so that they look realistic is a challenging game for Lundin. To make the game easier, he thinks about objects in terms of their shape more than their function. Make a drawing of a pretend place that looks real but is not. Arrange things to look just right even if they don't really go together.

ESTIMATED TIME: 1—1½ HOURS

 **MATERIALS**

- Pencil
- Colored pencils or chalk pastels
- Drawing paper

 **STEP BY STEP**

*Planning*

Walk around your house or classroom and make a series of quick sketches of ordinary things that you can find on a wall. Ideas include baseboards, an electrical outlet, a doorway, a coat on a hook, a clock, a fireplace, and so on. Organize the things on your paper by the geometric shapes that they make: group rectangles, squares, circles, and triangles together and find several examples of each.

Find something that sticks out from the wall and sketch it. You can draw a cord like Lundin did, or find something else.

*Learning from Lundin*

Look back at *Yellow Towel in Studio* and notice how Lundin stacks things that have a triangular shape on top of each other: the shadows from the window, the towel, and the hanging lamp. Find other places where he repeats shapes.

*Drawing*

- Put it all together. Look at your sketches and decide where your objects will go.
- On a separate sheet of paper, make a light sketch that is an arrangement of objects on a wall. Move them around until they look just right based on how they look against the

other geometric shapes. Look at the spaces between objects and shapes. Make interesting negative spaces between things.

- Add some things that extend out from the wall and out of the picture.
- Step back from your artwork. Do you want to move an object to another part of the artwork to make it look more balanced? If so, erase it and put it someplace else.
- Once you are pleased with your composition, add color to your artwork.
- The towel in Lundin's artwork stands out because it is the only object that is yellow. Do you have something that you could make stand out?

*Tip:* You can create lots of different types of effects using colored pencils or chalk pastels. You can layer one color over another to make new colors. Draw red over yellow to get orange, or draw black lightly over white to get gray. If you press down more firmly or more softly you can get a variety of shades.

*Thomas, Age 11*

## EXPLORE MORE
*Small Moments with a Twist*
Lundin takes an ordinary scene and gives it a twist. To spark our imagination, he likes to add something odd to his artwork, like a cord that goes nowhere. You can do it too. What if you were brushing your teeth and the mirror became a window? What are some other odd things that could happen? Write about a small, everyday moment, but add a twist or two that takes you to a slightly strange place. Be sure to share and celebrate!

*Think About It*
If you had a magical cord, what would it do? Why?

*Learning Focus*
Language Arts

### MORE ABOUT THE ARTIST
**NORMAN LUNDIN** (1938–  ) always wanted to be an artist. And now, people everywhere are drawn to his imaginative visions of everyday objects and scenes. His artwork—featuring blackboards, fire hydrants, glass jars, landscapes, and more—can be found in the collections of the Museum of Modern Art, the Art Institute of Chicago, and the Seattle Art Museum.

# DISCOVER PLACES IN THE SUN

Pierce Milholland, *Summer Picking*, 2002
oil on canvas, 30 x 30 inches

When you make a picture of a sunny day, do you include the sun? In this picture, Pierce Milholland created sunlight without painting the sun. Let's discover how he did it.

Can you find three or more things that are lit up by the sun? Pick out leaves that seem to have more light on them than others. Did you spot the patch of light on the apple picker's chin? How has the sun changed the color of the ladder? On sunny days, the metal of a ladder acts like a mirror, reflecting the blue color of the sky.

Point to places where you can see the sky through the trees. Why do you think the blue patches are darker in some areas than others?

Let's learn about some artists' tricks. Pull the picture up close to you. Which colors pop out? The bright red and green dots of color help each other look brighter. They are called complementary colors.

Push the picture away to see it at a distance. Move your finger from left to right, following the red patches of color across the page. What sort of imaginary line did you trace? Milholland placed vivid splashes of red around this painting to make us move our eyes all around the artwork, just like we saw Jacob Lawrence do earlier in *Windows*.

Though we can't see the sun, can you figure out where it is in the sky? Look at the light and shadow on the apple picker's hat for a clue. Make a fist. Pretend it is the sun and move it around until you have decided where it should be in the sky. With the sun overhead, is it noon and time for lunch? Maybe the picker needs to fill his basket first. Milholland had a great respect for farm workers and he loved to paint them hard at work harvesting crops or tilling fields.

Remember these tricks next time you make art about a sunny day: hide your sun, but change the colors of objects and the sky to show the sun's light and shadows.

**COMPLEMENTARY COLORS** are pairs of colors opposite one another on a color wheel.

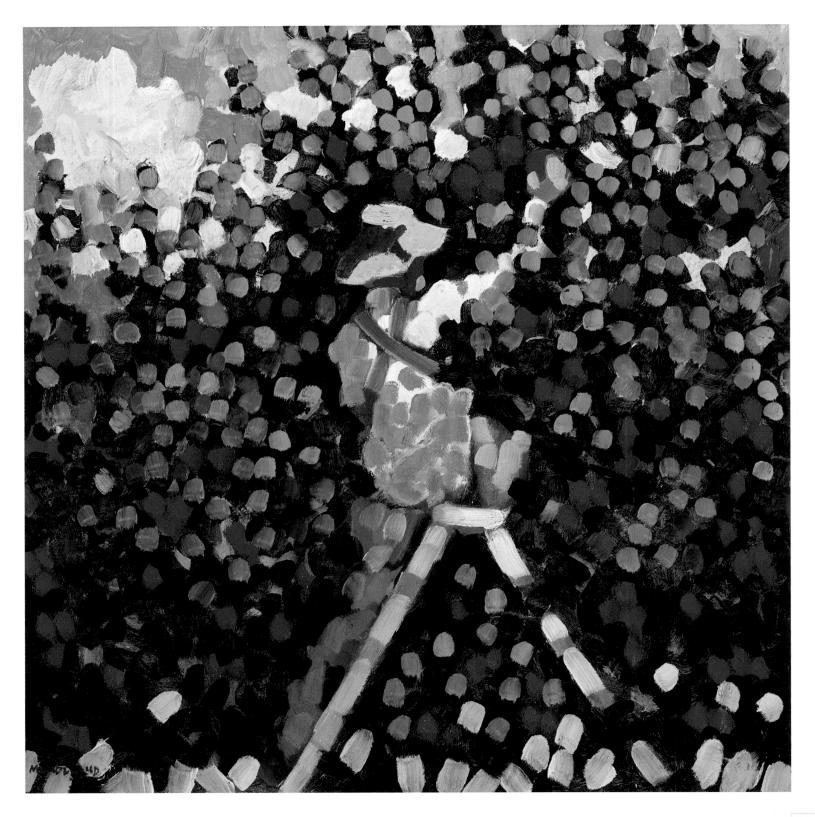

# MAKING ART AFTER LOOKING AT ART: *Trees in Sunlight*

## MAKE A PAINTING OF SUNLIT TREES

Have you ever noticed how sunlight makes some leaves on a tree appear brighter than others? What does it look like when the sun shines through leaves on a tree onto the ground? This simple observation of how light affects natural forms inspired Milholland to paint *Summer Picking*. He took an everyday scene and transformed it into something quite special. Now you try.

ESTIMATED TIME: 1 HOUR

 **MATERIALS**

- Tempera paint (primary colors and white)
- Water
- Palette (a large plastic lid works well)
- Sturdy paper and scratch paper
- Foam brush and firm paintbrushes
- Photographs of trees in sunlight

 **STEP BY STEP**

*Planning*

- You may choose to take your supplies outside and paint on the spot. Many artists enjoy painting outside. They call it *en plein air* which is French for "outdoors."
- Observe how sunlight changes the colors of trees as well as the ground below. Or look through photographs that show the effect of sunlight on things. Notice how the sun shining through a tree makes things below look like they are sprinkled with light.
- Look back at *Summer Picking* to see how the artist used dabs of bright and dark colors and short brushstrokes to capture sunlight on the tree. How many shades of green did he use? Notice how he created the effect of dappled sunlight.
- You can mix your own colors too. Squeeze out yellow, red, blue, and white onto the outer edges of your palette. To make green, mix a little blue and yellow together. Add white to make a light green, or add a touch of red to green to make it duller. Add even more red and you will get brown (which will come in handy if you need to paint tree branches). What other colors can you make?

## COMPLEMENTARY COLORS

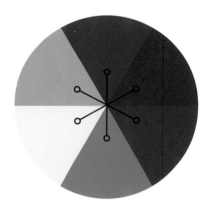

In the above color wheel, colors shown opposite of each other are complementary.

## Painting

- Begin with the sky. Create a wash by diluting paint with water. Using a foam brush, paint a wash over the entire surface of a sheet of paper. Use more than one color of wash if you need to. You may want to add swirls of white on top to show billowing clouds and moving air.
- Paint your tree(s) on top of the wash using dabs and strokes of colors. If your tree has fruit or flowers, add those colors too. Allow for areas of sky or clouds to show through the leaves and branches to show depth.
- Wait for your painting to dry. Take a step back and look at it again. Does your painting show sunlight without including the sun? Add more colors and shades if necessary.

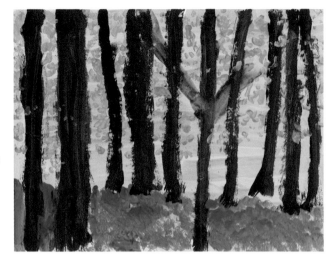

*Elliot, Age 7*

## EXPLORE MORE

### Adopt a Tree

Find a tree at your school or in your backyard. Create a science journal and observe the changes the tree goes through over the course of a year. Use photographs, notes, and diagrams to record your findings.

### Think About It

How does the amount of daylight affect the tree? What about the temperature? The weather?

### Learning Focus

Science

### MORE ABOUT THE ARTIST

**PIERCE MILHOLLAND** (1935–2005) was born in Philadelphia and went to college at Yale. He moved to Seattle, studied architecture at the University of Washington, and became a full-time architect and part-time painter. As time passed, his passion for art grew and he realized he wanted to be a full-time painter and part-time architect instead, which he did. That passion for art stayed strong, and he once said, "Those who now own my paintings own a very real part of me. Some paintings are distant now, but I can remember all the brush strokes, the color choices, and all the choices in between..."

# DISCOVER STORMY PLACES

Guy Anderson, *Channel Meadows by Storm*, 1959

oil on linen canvas, 31½ x 50 inches

Close your eyes. Picture a powerful storm racing across the sky. What do you see? Can you hear thunder rumbling? Do you feel the wind and rain against your face? The force of a storm may also make you feel small and powerless.

Let's look closely at *Channel Meadows by Storm* and discover how Guy Anderson shows nature's power. Run your finger along the gray lines in the sky near the top part of the picture. What types of lines and shapes did you find? Can you see how these jagged lines pull your eyes up and down?

Usually clouds are rounded, but here they are angular. Why would an artist choose to change nature's forms? Maybe he felt that these sharp angles helped him express the mood of a storm as its strength grows.

What do the colors of the sky tell you about the weather? Find some clouds that look heavy with rain. Can you find places where the sun peeks through? Sunlight can be light yellow, or white in some places and orange in others.

Look down at the plowed fields of the landscape. How are these parallel lines different from the lines in the sky? Can you see how Anderson shows us perspective? The diagonal lines pull your eyes away from the foreground and toward the angry storm in the background.

Although we recognize some parts of this picture, other parts will always keep us guessing. What do you make of those large geometric shapes to the left? Does this area remind you of buildings or maybe a rocky cliff?

*Channel Meadows by Storm* was painted a few years after Anderson had removed himself from the hustle and bustle of Seattle city life. He said that he had to move to the country otherwise he would "go to pieces." He settled into a peaceful, simple life in the small village of La Conner, Washington.

Daily walks through the farm fields near his home made him feel connected to nature. He once said, "There is something about the long vista that we have out here which I like very much. There is a stretch of just pasture and sky." When he returned to the quiet of his studio he felt inspired to paint nature's energy. How does nature inspire you?

**PERSPECTIVE** is a way of arranging things on a flat piece of paper to make them look like some are close up (**FOREGROUND**) and some are in the distance (**BACKGROUND**).

# MAKING ART AFTER LOOKING AT ART: *Landscapes and Sky*

### DRAW A LANDSCAPE THAT CAPTURES THE WEATHER

The natural beauty of the Pacific Northwest greatly inspired Anderson. He made frequent trips to the mountains and the beach to sketch and experience the outdoors firsthand. Back in his studio, he painted expressive lines and shapes to convey unstoppable forces of nature, like the energy of a storm as it approached land. Now it's your turn to create a landscape that shows the feeling of weather.

ESTIMATED TIME: 1 HOUR

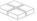 **MATERIALS**

- Pencil and light-colored chalk
- Oil pastels
- Sturdy paper

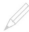 **STEP BY STEP**

*Planning*

- Think about how different types of weather affect the sky. Make a list of climate conditions and describe how the sky looks in each type of weather. Ideas may include: sad on a rainy day, angry during a storm, wild on a windy day, or peaceful on a sunny day. What type of weather system do you want to portray?
- Try this exercise to learn how lines can show feelings. On a piece of paper, draw lines and shapes that are sad, happy, angry, wild, and peaceful.
- Find a landscape to draw. Go outside to your favorite place where you can see land and sky, or look at photographs, magazines, or the Internet for ideas. Calendars might have some great images as well.
- Set aside oil pastels that match the colors in your landscape and weather system.

*Sketching*

- Using chalk, make a light sketch of your landscape. Begin by drawing the horizon line, where the sky and earth meet. Draw simple outlines of other things you see like trees, hills, fields, and clouds.
- Anderson tried to paint nature as if it were alive. He once said, "I am interested in the magical insight of things." Now you try it.

- Draw over your chalk lines with oil pastels. Draw in landscape features using expressive lines and shapes. You can look back at your practice page for ideas. Use the sides of pastels for larger areas. For an interesting effect, you can layer one color on top of the other like Anderson did.
- Finally, use your oil pastels to make lines and shapes in the sky that convey the type of weather conditions and its mood.

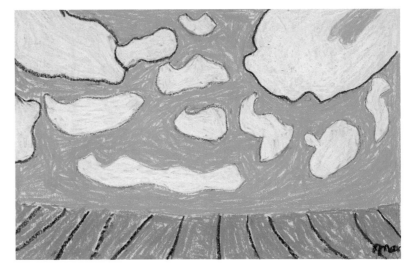

*Max, Age 12*

## 🔍 EXPLORE MORE

*What's in a Name?*

Look at Anderson's artwork again with a friend. This time play Beethoven's *Symphony No. 6 in F Major, Op. 68, No. 4 ("Pastoral")* while you look and imagine the artwork is a window to the gathering storm. Write a list of adjectives and weather-related words as you look and listen. Create a new descriptive title for the artwork. Share it with your friend. What does the music add to the artwork?

*Think About It*

What other forces of nature are awesome? How do they make you feel?

*Learning Focus*

Science, Language Arts

### ✏️ MORE ABOUT THE ARTIST

When **GUY ANDERSON** (1906–1998) was six years old, his teacher showed him some woodblock prints from Japan. Seeing the Asian prints sparked a lifelong interest in all kinds of lines, from curves to spirals to diagonals. Anderson's distinct style earned him a place alongside Mark Tobey, Morris Graves, and Kenneth Callahan in the "Northwest School" of artists.

# DISCOVER PLACES AT NIGHT

Paul Horiuchi, *Fantasy at Night*, 1962
collage of rice and mulberry papers, 21½ x 35½ inches

The fun of abstract art is that we all see it differently. Take some time to explore this glued paper artwork called a collage. What do you see?

While you may see this collage in a particular way, look at it again—this time as Paul Horiuchi saw it as a *Fantasy at Night*. What do you see that reminds you of nighttime? Look at the large empty black space near the top part of the artwork. Some see this as the night sky. If you look closely you can find a line where the night sky appears to meet the dark water; this is called the horizon line. Can you make out anything else in the distance? What could the white sliver in the middle of the black space be? Perhaps it is a small island, or moonlight shining on the water.

Can you find other places where the moon is casting its light? Perhaps the white shapes near the middle of the artwork are rocks glistening? Could the dark spaces be small caves? If not, what else could they be?

Let's turn back the clock to when this artwork was just a pile of hand-painted papers spread out on the artist's worktable. Point out all the colors that he used. Look closely; you may be surprised how many you find. Horiuchi worked hard to get the shapes he wanted. He sometimes tried twenty different pieces of paper before he got the right one! Use your finger to trace all the different shapes he made.

Why do you think an artist would choose to make an abstract artwork rather than a realistic one? For Horiuchi, making abstract art was more interesting. He found this out when he was making an artwork of a dragon for a celebration in Seattle's Chinatown. He said, "I had done it in collage. I didn't like it. The dragon looked too bright. So I stripped it off. When I saw the traces it left, I realized it was much more interesting that way, so I just let it be."

This discovery inspired Horiuchi to explore the power and mystery of abstract art. In fact, after this experience he never returned to making art that was realistic. If your artwork doesn't turn out the way you imagined, don't throw it away. Look at it again. Perhaps you'll be inspired to try a new way of making art.

**ABSTRACT ART** does not try to show people, places, or things as they really look. They may be exaggerated or simplified. Sometimes abstract art is just about lines, shapes, and colors.

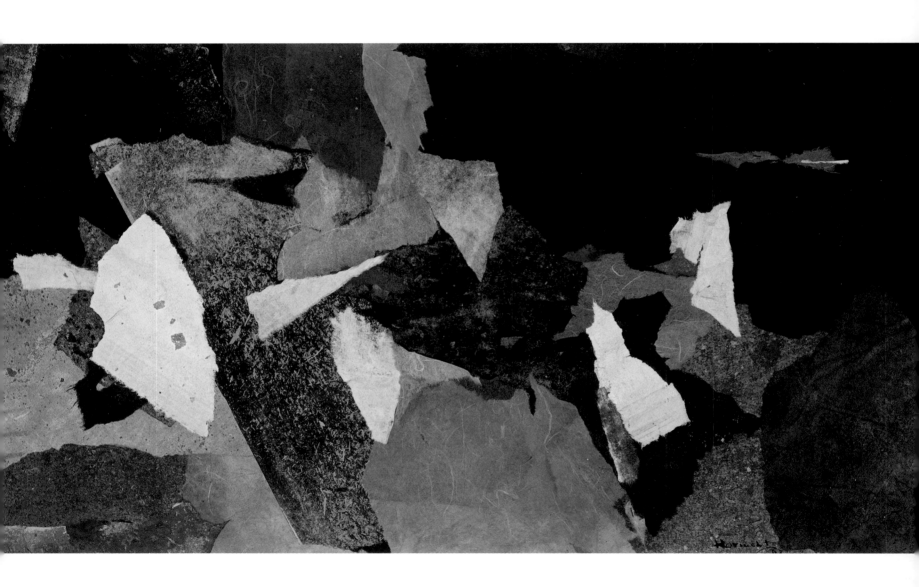

# MAKING ART AFTER LOOKING AT ART: *Torn Paper Landscapes*

## USING PIECES OF TORN PAPER MAKE A LANDSCAPE COLLAGE

Once, when Horiuchi was taking a walk, he noticed how old posters glued to storefronts had been peeled away in layers by weather and time, making interesting abstractions. This inspired him to explore how abstract art can communicate moods and ideas. Now you try it. Make a collage that represents the mood of a natural setting.

ESTIMATED TIME: 1 HOUR

 MATERIALS

- Photographs of landscapes
- Earth-toned construction paper (for example, blue, brown, tan, green, black, and white)
- Glue

 STEP BY STEP

*Planning*

- Look through photographs from a family trip, or at magazines or books that show scenes from the outdoors. Choose one that you like. You could also go outside and make a collage from what you see.
- Think about the landscape. What mood does it convey? Is the scene peaceful and calm, or does it feel like another emotion?
- Look at your picture. What four earth tone colors do you want to use? How will the colors you choose help you communicate the mood? Choose one of these colors to be the ground or base (the piece of paper on to which you will glue your collage). Choose one additional color as an accent color. Horiuchi chose red.

*Creating*

- With your landscape as inspiration, tear papers into geometric shapes that express the mood of the scene.
  *Tip:* Give yourself plenty of time to put the pieces in place before you glue.
- Play around with layering and arranging the pieces of paper. Think about how the colors and shapes make a person's eyes travel around your picture.

## Learning from Horiuchi

Colors have a job in an artwork. Look back at *Fantasy at Night* to see where Horiuchi placed colors to make our eyes move. Look how the white papers are spread out across the picture. Do you see the importance of that splash of white in the water? The color red has another job. Cover up the small patch of red paper with your hand. Is there anything left to catch your eye? Learn from Horiuchi and use at least one of his tricks in your collage.

Glue down the papers once you are satisfied. Give your collage a title that describes the landscape *and* its mood.

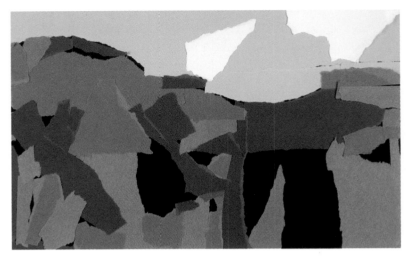

*Colin, Age 8*

## 🔍 EXPLORE MORE

### Poetry at Night

Close your eyes and imagine that you could slip inside *Fantasy at Night.* What would it be like? Make a list of words that describe what you see, hear, smell, and feel. Use these words to write a *haiku*, a Japanese form of poetry, about the night. A haiku has 17 syllables: five in the first line, seven in the second line, and five in the third line. You'll have to use descriptive language to pack as much meaning as you can with the fewest words possible.

### Haiku Example

> *Moonlight glistening*
> *Whispering on the water*
> *A calm quiet night*
> *—Henry, Age 12*

### Think About It

How do you feel about the night? Why?

### Learning Focus

Language Arts

---

### ✏️ MORE ABOUT THE ARTIST

**PAUL HORIUCHI** (1906 –1999) grew up in Japan and one of his earliest childhood memories was watching traveling artists who stopped in his village to paint images of Mount Fuji. "I began painting as a child," he once said, "but I never expected to be a professional painter. I painted for fun." Today, his artwork is displayed in museums all over the world.

# ANIMALS IN ART

What's your favorite animal? Everyone has one. From beloved pets to mythical forest

creatures, the animals in this section teach us about tenderness, strength, and even the

power of dreams. Take time to look closely at each of the following pieces. Do they remind

you of animals you know?

# DISCOVER ANIMALS AS MEMORIES

Jose Orantes, *Leopard's Soul*, 1990
acrylic on canvas, 27 x 57 inches

See-through leopards . . . people made with layered patterns and bright colors . . . why do you think Jose Orantes painted them to look this way? Let's learn more about this artist and discover why he created this perspective.

Raised in Guatemala, Orantes moved to Seattle in 1978. The lush tropical landscape of his homeland is very different from the Pacific Northwest. Orantes's paintings help him remember where he grew up. He once said, "The colors I use remind me of how the sun in Guatemala embraces everything and lights things up."

What else can *Leopard's Soul* teach us about Orantes's childhood home? What do the curved green, orange, and turquoise motifs look like? They may represent slices of tropical fruit that he saw at a local market. Can you imagine what natural forms inspired the leopards' fur and spots?

Orantes said that the plowed fields near his home looked like a "beautiful tapestry." They inspired him to use patterns in his art. Can you see how the women's hair could look like rows in a field?

The vibrant colors and crowded patterns keep our eyes busy, but now take a look at the transparent leopards and people. "I was interested in how the design on top changed the colors in the back," Orantes explained. In a jungle, a leopard's spots provide camouflage so that it can sneak up on its prey or avoid being seen. Are the leopards hiding the people in this picture? Or maybe the people are providing camouflage for the leopards? Stare at this picture until the people and leopards look like they are moving back and forth. Can you make them appear to become one?

Now think about the title. Why do you think Orantes named this painting *Leopard's Soul?* Try to imagine this as a photograph of animals and people. How would that change the meaning of the painting? Do you think it would tell us a different story?

Art can be a window into an artist's mind. When Orantes pulls colors and images from Guatemala's rich landscape into his painting, he gives us a glimpse into his memories and imagination.

A **MOTIF** is a shape, line, color, or image that may be represented in an artwork to form a pattern.

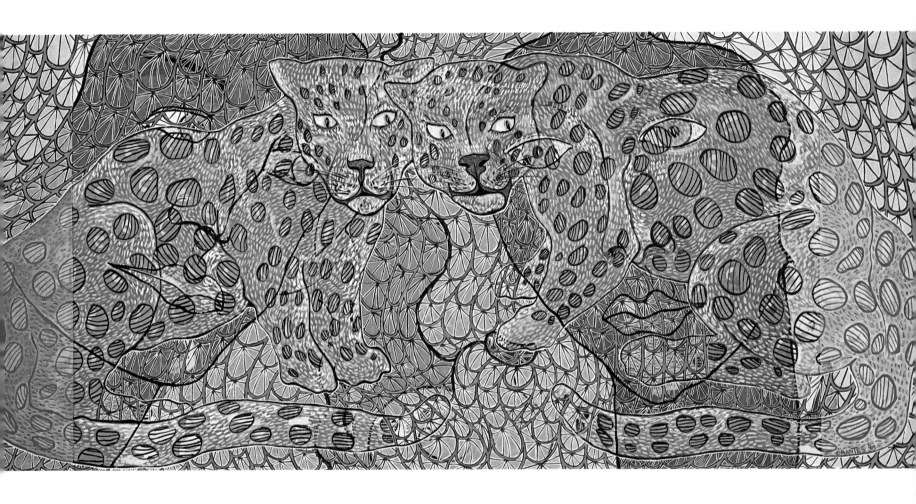

# MAKING ART AFTER LOOKING AT ART: *The Place Where You Live*

## MAKE A PICTURE THAT REPRESENTS WHERE YOU LIVE AND INCLUDES MOTIFS FROM NATURE

Even though Orantes now calls Seattle his home, he includes vibrant colors and organic patterns in his artwork that remind him of Guatemala, where he grew up. Pretend that you have moved to a new place that is very different. Draw a picture that shows where you come from.

ESTIMATED TIME: 1—1½ HOURS

 **MATERIALS**

- Drawing paper
- Colored pencils
- Black permanent marker

 **STEP BY STEP**

*Planning*

- Imagine leaving your home and moving to a place that looks completely different, like the desert or the tropics. What would you miss most about the landscape you left behind? What animals remind you of your region? Brainstorm a list.
- Take a walk outside. Notice the colors that you see around you. Collect some natural forms that are native to the region, such as fern leaves, pinecones, pine needles, moss, etc.
- Look back at *Leopard's Soul* and notice how the painting is filled with simple natural forms, or motifs, that are repeated over and over again.
- Look at your collection of natural forms. Which ones can you transform into simple designs or patterns? Sketch some ideas on a piece of paper. Set these aside; you'll come back to them later.

*Drawing*

- On a sheet of drawing paper, lightly sketch an outline of a natural form that reminds you of your homeland. Ideas: mountains, pastures, trees, flowers, lakes, or ocean beaches.
- Sketch a silhouette of an animal that lives in your region. You may choose to have parts of the animal overlap your natural form.
- Go over your outlines with a thin black permanent marker to make your images stand out.
- Choose colors that are found in your environment. Look back at your sketches of designs. Use repeating patterns to fill the entire picture with colored motifs inspired by natural forms.

## ⌕ EXPLORE MORE

*Animal Homes*

What do you know about the tropical rainforest? Learn about an animal that lives in this complex ecosystem. Imagine if this animal was moved from that environment. How would this affect the rainforest and the other creatures that live there? Make a shoebox diorama that shows how the animal is connected to the rainforest through the food chain and other parts of the habitat. Write about what happens when you remove one animal species.

*Think About It*

Are humans more adaptable to new environments than animals? Why or why not?

*Learning Focus*

Science, Language Arts

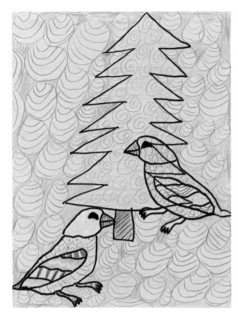

*Izabella, Age 9*

### ✐ MORE ABOUT THE ARTIST

When **JOSE ORANTES** (1958–   ) first moved from Guatemala to Seattle, he thought, "So many bridges, cars, hills, houses, and people!" He decided to make Northwest scenes more cheerful by painting them in the vivid colors of his homeland. From bright green to deep magenta, the lush colors of the jungle were merged with the imagery of the Pacific Northwest. Orantes once said, "In my work I apply colors that give life movement and emotion."

# DISCOVER ANIMALS IN A DREAM

Elizabeth Sandvig, *Dreamer and White Horse*, 1988
acrylic, 25¾ x 25¾ inches

Ssshhh . . . someone is trying to fall asleep. What does it feel like when you slowly drift off? Does the real world slip away? Let's look closely at *Dreamer and White Horse* and see what it feels like for artist Elizabeth Sandvig to slip into a dream world.

Point to a curvy gray line that seems to separate the painting into two parts. Is it a stream? What else could it be? Maybe it is the space between being awake and sleeping. Which parts belong in a dream? Do you think that the abstract areas belong in the dream world? What could they represent?

People sometimes wonder if horses dream. Maybe Sandvig believes that they can. What could her horse be dreaming? What do you think the person is dreaming?

Do you have a dream that you love? Or a dream that you've had repeatedly? Sandvig had a recurring dream about a white horse. She learned to ride horses as a young girl growing up in Washington, D.C. To pass the time while traveling through the countryside, she would count the white horses she could see in the fields. Maybe the horse in this painting is one she remembers from her childhood.

In this picture, the person and horse are in a space of their own. How did they get there? Paintings can be puzzles. Do you want an artist to tell you everything, or do you like it when there is some mystery about an artwork? Note which places in the artwork you are curious about.

The sky-blue window will always be a mysterious part of this painting. What would we see if we could peek inside? Perhaps we would see the rider taking a nap next to a horse.

The dreamer and white horse were painted on a separate piece of paper and then attached to the surface of the painting. What does this add to the story? Sandvig is married to Michael Spafford, another artist featured in this book. Spafford sometimes cuts out pieces of his artwork and glues down something else in its place. Often times artists borrow ideas from one another. Perhaps she changed her mind about what should be in her picture, or maybe the idea came to her while drifting off into a dream.

# MAKING ART AFTER LOOKING AT ART: *Dreamscapes*

## MAKE A PAINTING OF A DREAMSCAPE OR A MYSTERIOUS SCENE FROM A DREAM

Horses and other animals are a big part of Sandvig's dreams and art. She often dreams about animals and they become the subject of her paintings. Most recently she dreamt she was swimming with several turtles. This dream became the inspiration for a series of paintings. What have you dreamed about doing?

ESTIMATED TIME: 45 MINUTES

### 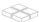 MATERIALS

- Watercolor crayons
- Paintbrush and a one-inch sponge brush
- Water
- Colored construction paper (light or dark blue work well)

### 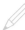 STEP BY STEP

*Planning*

- Sometimes dreams are hard to remember. Try keeping a dream journal for several days. When you wake up, quickly draw scenes from your dream.
- Choose a dream that you want to depict in an artwork.

*Making a Dream Square*

- Using watercolor crayons, draw a scene from a dream on a small square piece of sturdy paper (about 4 x 4 inches). This is your Dream Square.
- Blend colors together by adding water with a brush. Set the Dream Square aside and allow it to dry.

*Making a Dreamscape*

- On one side of a large piece of paper, draw a simple picture of your house that includes your bedroom window.
- Create a dreamscape environment around your house that includes some parts that are recognizable and others that are more abstract. Choose colors that help communicate the mood of your dream.

## Tips for Using Watercolor Crayons

- Use a brush or sponge brush to blend in colors for a watercolor effect.
- Dip the watercolor crayon tip into water and then draw on the paper.
- Go back in again on top of your painting with watercolor crayons and add details, or lines to define forms or shapes.

## Putting It All Together

- Lastly, take the Dream Square and find the right place for it on your dreamscape. Glue it down in place.

### EXPLORE MORE

*Animal Visions*

Have you ever daydreamed and created a movie in your own mind of something you would like to experience? Now is your chance to give your imagination a workout! Take some time to daydream. Pretend you are an animal. If your animal could talk, what would it say? How does it feel about humans? What does your animal dream about? Turn and tell someone what your mind movie was about!

*Think About It*

If animals could talk to humans, what might they tell us? Why?

*Learning Focus*

Language Arts

*Elizabeth, Age 12*

### MORE ABOUT THE ARTIST

**ELIZABETH SANDVIG** (1937– ) began to take art lessons when she was seven years old and living in Washington, D.C. She moved to Mexico City as a teenager and then to Seattle as an adult. Her paintings and prints can be seen all around Seattle—at the Seattle Art Museum, Microsoft, the University of Washington, and more.

# DISCOVER ANIMALS THAT ARE LOVED

Catherine Eaton Skinner, *Dog Days of Summer II*, 2000
encaustic, 24 x 28 x 2 inches

What do you notice about this dog? Where might he be heading, or where did he come from? Look closely at how he is standing; perhaps his paws will give you a clue. What do you think has stopped him in his tracks? Drop down to all fours and try to copy the way the dog is standing. Have someone describe your pose. Do you look lost, as if you are searching for your master? Maybe you look as though you have just come home after a long day of exploring and are distracted by an interesting smell.

Let's look further. Turn the book upside down. Take your hand and cover up the dog and look closer at the long diagonal shadow. You may not see it right away, but artist Catherine Eaton Skinner said she painted the shadow to resemble a person. Run your finger around the shadow and see how it could look like a person as well as a dog. Turn the book upright. Why do you think she chose to join a person to the dog?

Skinner has raised many animals and has a special love for dogs. Losing a puppy to an accident was a painful experience for her. For most of the next year, she found that all she could paint were dogs. Why might an artist choose to paint at a time when they were sad? Art can be a way to keep memories alive after suffering a loss; it also can help you understand or accept something that is quite upsetting. Have you ever had a pet that died? Or have you ever lost a special belonging that you can't replace?

Now let's look at the setting. Where do you think the dog is standing? This artist decided to make that question hard to answer. Why do you think she did that? Perhaps this will help us understand. Close your eyes and think again about a pet or special possession that you have lost. Keeping your eyes closed, tell someone what you see. What did you describe? Chances are your mind focuses on the beloved pet or cherished lost item rather than the details of a setting.

How do you feel about what you see in your mind? Share those feelings with a friend. Now, think about a way that you could make a work of art that shows your love for an animal or for something that you have lost. What a great way to keep that feeling and memory alive.

# MAKING ART AFTER LOOKING AT ART: *My Favorite Animal*

## DRAW A PET OR ANIMAL THAT YOU LOVE

Skinner often makes art that celebrates the natural world and the creatures that live there. Animals play a big part in her life and hold a place in her heart and mind. Make a drawing about an animal (pretend or real) that you admire or love.

ESTIMATED TIME: 1 HOUR

 **MATERIALS**

- Pastels or watercolor crayons
- Piece of scratch paper
- Pastel paper or colored construction paper
- Brushes, including a one-inch sponge brush
- Hair spray or pastel fixative to set pastels

 **STEP BY STEP**

*Experiment with Drawing Media*

Using a pastel or watercolor crayon, draw many different types of lines. Use the side or the tip to see how you can make thick and thin lines. What happens when you press down hard and then softly? Try layering colors, one on top of the other. Blending pastel colors with your fingers or a paper towel gives a different effect. See what happens when you add water to your pastel or watercolor drawing with a brush. Try to use some of these techniques in your picture.

*Planning*

- Do you have a pet or an animal that is very special to you? Close your eyes and think about your animal. What do you see?
- Practice showing your emotions through art. Think about the love you feel for your animal. On a piece of scratch paper, use two or three pastels to show the emotions of love with only colors and lines. Do not draw recognizable pictures or images. Set this aside for later.

*Sketching*

- Look back at the dog in Skinner's painting. Notice how he is in the top right hand corner of the page. Why do you think she chose to put him there? Think about placing your animal off center too.
- Draw your pet or animal. Use a light-colored pastel to sketch a simple outline. Start with the head, then add the body.

- Now think about the setting. Use only a few lines to give a hint of whether your animal is inside or outside.

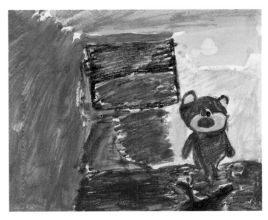

*Casey, Age 8*

*Adding Color*
- Look back at Skinner's artwork and notice how she blended colors together.
- Take a look again at your scratch paper. Add some of the techniques that you tried out and use colors and lines that express your feelings.
- When done, spray your artwork with hair spray or pastel fixative to prevent smearing.

## EXPLORE MORE

*Poetry About Art and Art About Poetry*

Skinner often writes poetry about her art because she believes that poems and visual art together allow her to express her ideas and feelings. After you have finished your artwork, write a poem about it. A *cinquain* format is fun and easy to use:

> *Line 1: Create a title for your artwork using at least one adjective.*
> *Line 2: Choose two adjectives that describe the title.*
> *Line 3: Select three verbs that describe the title.*
> *Line 4: Write a short phrase or question for your artwork.*
> *Line 5: Repeat the title from the first line.*

Here is one Skinner wrote about *Dog Days of Summer II*:

> *blue shadow beneath*
> *still red dog*
> *watching, waiting, wary*
> *protecting all directions*
> *blue shadow beneath*
> *—Catherine Eaton Skinner, 2009*

*Think About It*

What if you wrote a poem first and then made art?
How are poetry and art similar to each other?

*Learning Focus*
Language Arts

---

### MORE ABOUT THE ARTIST

**CATHERINE EATON SKINNER** (1946– ) currently divides her time between Seattle and Santa Fe, working as a painter, sculptor, printer, and photographer. She is also a passionate dog lover, especially of Ingrid, Sigrid, Ellie, Sasha, Nellie, and Maddie, to name a few. As she says, "I have never 'owned' my dogs. They have been and are a gift, wrapped in kisses and warm, soft ears."

# DISCOVER ANIMALS AS SYMBOLS

Sherry Markovitz, *Our Father*, 1980
mixed media (oil paint, beads, and sequins), 53½ x 48½ inches

How can you paint something that you can't see or touch, like feelings? Sherry Markovitz has found a way that works for her—she uses animals. She explains, "It is easier for me to say what I want to say through animals because they communicate with us without using words."

Let's look at this doe to see if you can understand her feelings. Look into her bright blue eyes. Is she afraid, or just curious? What would happen if you took a step toward her? The doe may at first seem calm but the slight tension in her body may be telling us she feels unsafe.

How is the background different from the doe? The contrast in textures makes the deer stand out. It's difficult for her to hide. Look around the glistening forest of sequins and beads. Markovitz makes it fun by hiding some unexpected details. Did you discover the dots of pink flowers? What else can you find? The row of sequins on the crown of the doe's head is a pleasant surprise!

Think about how long it would take to stitch each bead onto this large canvas. Markovitz says that beading "quiets me down. Working slowly on an artwork is meditative." Often it takes months for her to finish an artwork.

Markovitz made *Our Father* at an important time in her life. "Shortly after my father died, I took a long road trip and I was taking a rest. I was lying under a grove of aspen trees and they were whispering and glistening in warm sunlight like sequins. It was beautiful. I thought of my father and soon after I made this artwork."

Have you ever found that feelings are difficult to put into words? Next time this happens to you, try making art. What animal would you choose to help you express your feelings?

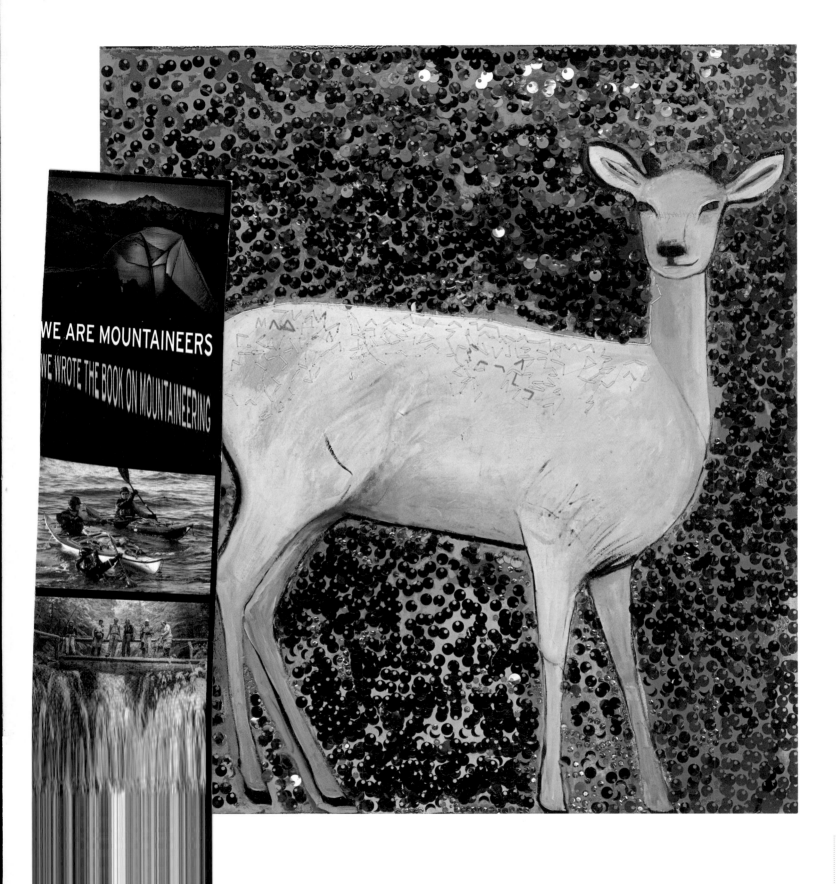

WE ARE MOUNTAINEERS

WE WROTE THE BOOK ON MOUNTAINEERING

# MAKING ART AFTER LOOKING AT ART: *Animals that Symbolize You*

## MAKE A PICTURE OF AN ANIMAL THAT REPRESENTS YOU

Markovitz often uses animals as stand-ins for herself or people close to her. If you were an animal right now, what would you be? Make an artwork that shows what you are feeling today.

ESTIMATED TIME: 1–1½ HOURS

###  MATERIALS

- Photographs of animals
- Paint
- Paper
- Sequins, beads, foil, and colored metallic paper
- Scissors
- Glue
- One-inch hole punch (optional)

###  STEP BY STEP

*Planning*

- We all have many different feelings. You may feel outgoing like a dolphin one day and shy like a mouse the next. Follow this exercise to figure out what animal best matches your mood and personality.
- Make a Sun/Shadow Chart that looks like the one below.
- Complete the Sun/Shadow Chart by following the directions in each column.

| SUN | SUN | SHADOW | SHADOW |
|---|---|---|---|
| ① | ② | ③ | ④ |
| *If you were an animal, what would you be? (for example: dolphin)* | *Pick an adjective that best describes that animal. (for example: outgoing)* | *Choose an adjective that is the opposite of the word in Column #2. (for example: shy)* | *Select an animal that fits the adjective in Column #3. (for example: mouse)* |

- Look over your Sun/Shadow Chart and decide if you feel like painting your sun animal or your shadow animal. Today you may feel like painting your sun-self, on another day your shadow-self. It depends on your mood.
- Find a photograph of your sun or shadow animal in its natural environment.

*Linus, Age 6*

### Painting
- Paint your animal so that it takes up most of your page. Make sure the animal shows its mood.
- Paint the background to represent the animal's environment (for example: a dolphin in blue water or a mouse in a field of green grass). Surround the animal in washes of color. Allow the paint to dry.

### Collage
- Look back at *Our Father*. Notice how Markovitz chose to make the doe stand out by making its flat surface contrast with the sequins in the background.
- Think about the qualities of your animal. Do you want the animal or its environment to stand out? You can glue sequins, beads, foil, and metallic paper to either the animal or the background. You can also use a large hole punch to make circular shapes.

*Tip:* Here's a great trick from Markovitz for keeping your fingers clean while gluing sequins. Dip the eraser end of a pencil in glue and then pick up sequins with it and glue them one by one on your paper.

### EXPLORE MORE
*Totems*
Many Native American cultures have totem animals that are used as a symbol of a tribe, family, or an individual. These animal symbols have certain character traits. Learn more about Native American animal symbols then choose three or more animals that remind you of yourself. Write a short paper that describes the qualities that you share with the animals.

*Think About It*
What animal totem would a friend choose for you? Why?

*Learning Focus*
Social Studies, Character Education

**MORE ABOUT THE ARTIST**
Since the beginning of her career, **SHERRY MARKOVITZ** (1947– ) has made art about animals. Sheep, donkeys, elephants, bears, and deer are some of her favorites. She always knew she wanted to be an artist, and her parents let her take classes at the Art Institute of Chicago when she was young. Now that she is grown, she gets joy and satisfaction from working with beads and other collected objects.

# ACKNOWLEDGEMENTS

## JUNIOR LEAGUE OF SEATTLE

*Committee and Membership Volunteers*

Thank you to the following Junior League of Seattle (JLS) Northwest Art 50th Anniversary Comm
their dedication and participation in Anniversary projects and for their help in making this book

### 2009-2010 COMMITTEE

Bonnie Marshall *Chair*
Lorna Kneeland *Vice Chair*
Julie Roberts *Vice Chair*
Tricia Tiano *Sustainer Advisor*
Susan Aley
Christine Alford
Nicole Ancich
Collette Collins
Shannon Corbin
Lynn De Koekkoek
Anne Derry
Jocelyn Diles
Kimberlie Gateley
Heather Giacoletto
Amelia Guess
Caitlin Haedicke
Michelle Haines
Heather Hall McDermott
Kate Jack
Cynthia Kelly
Gillian Marcott
Jennifer Margolin
Jennifer Masse Zabel
Nicole McKinley
Ashley Miller
Joanne Petitto
Heidi Rogers
Suzanne Rouaix
Emily Sinclair Garnish
Mackenzie Sorich
Sara Stolte
Christine Treece
Kelley Umphrey
Amy Whiting

### 2008-2009 COMMITTEE

Bonnie Marshall *Chair*
Becky Allardice *Vice Chair*
Tricia Tiano *Sustainer Advisor*
Susan Aley
Holly Benedict
Ann Boberg
Vanessa Boys Smith
Candice Caldwell
Kelly Cross
Lia Davidovich
Heather Giacoletto
Kate Jack
Cynthia Kelly
Colleen Kerr
Heather Loke
Cynthia Lou
Lee McFadden
Sarah Morris
Joanne Petitto
Erin Phillips
Jenny Senh
Annie Shimotakahara
Martha Siegert
Oriona Spaulding
Karianne Stinson
Carrie Swint
Kristi Vellema
Dana Vetter-Min
Cassie Walker Johnson

### 2007-2008

Marie Maxwell
Elizabeth Arga
Dee Dickinson
Heather Giaco
Ann Kirtman
Bonnie Marsha
Rhonda Neben
Joanne Petitto
Tricia Tiano
Ayesha Zulqern

*Additionally, thank*
*commitment to this*
Maggie Adams
Natalie Bow
Stacy Chalfont
Mary Chapman
Corinne Cowan
Leslie Decker
Jenny Diamond
Marcella Diamor
Laura Garcia Pe
Fran Graham
Susan Hubbard
Megan Isenhowe
Jeanette James
Beverly Jefferson
Jennifer Loy
Maria Mackey
Andrea Mann
Sue Minahan
Erin Moyer
Alexis Phelps
Elizabeth Riley
Betty Rubenstein
Faith Sheridan
Rachel Strawn
Janet True
Nancy Webster

## THANK YOU TO THE FOLLOWING CONTRIBUTORS

| | |
|---|---|
| 2008-2009 | Junior League of Seattle Board of Directors |
| $21,500 | Fran Graham and Sharon Bingham |
| | (O.D. Fisher Charitable Foundation) |
| $5,000 | Joanne and Clayton Jones |
| | Tricia Tiano and Kent Mettler |
| $2,000 | Tory Burch, LLC |
| $1,000 | Leslie Decker |
| | Dee Dickinson |
| | Joyce L. Turner |
| $500-$999 | Natalie Bow |
| | Carolyn Echelbarger |
| | Lorna and Jim Kneeland |
| | Kelley McLaughlin |
| | Erin Moyer |
| | Joanne Petitto |
| | Andrew Pollack |
| | Elizabeth Reilly |
| | Nancy and Alan Sclater |
| $250 –$499 | Ashley and Craig Baerwaldt |
| | Caitlin and Nick Echelbarger |
| | Heather Giacoletto and David DeVisser |
| | Cynthia Kelly |
| | Bret Lathrop |
| | Tara Rose-Large |
| | Karen Todd |
| | Niki Weiss |
| $100-$249 | Susan and Doug Aley |
| | Kari and Troy Blanton |
| | Stacy and Roger Chalfont |
| | Cynthia and Cullen Davidson |
| | Deborah Dexter |
| | Laura and Curtis Fowler |
| | Jen Gill |
| | Sheri Halling |
| | Laura and Kenik Hassel |
| | Jeanette James |
| | Ali Johnson |
| | Sarah Kohut |
| | Kyle Lunde |
| | Dana and Joseph Manalang |
| | Bonnie Marshall |
| | Travis and Shanna Marshall |
| | Kimberly Morris |
| | Rhonda Neben and Mike DePuydt |
| | Carol Nissen |

| | |
|---|---|
| | Christie Peterson |
| | Lynn and Jeff Petillo |
| | Jennifer Peyree |
| | Stephanie Reeves |
| | Katrina Strand |
| | Nancy Webster |
| | Russ Woods |
| Up to $100 | Laurie Allen |
| | Melissa Anderson |
| | Pamela Arcilla |
| | Bob Barenberg |
| | Julie Bennet |
| | Angie Bentler |
| | Aaron Branstetter |
| | Debora Centioli |
| | Crystal Clarity |
| | Beth Douglass |
| | Kathi Effenberger |
| | Jennifer and Lucas Forschler |
| | Nikki Fralick |
| | Robin Francis |
| | Bridgette Franke |
| | Jenny Jones |
| | Dan Kaiser |
| | Morgan Kokenge |
| | Bonnie Larson |
| | Katherine Larson |
| | Ann-Marie Linde |
| | Andrea Mann |
| | Kyle McEligot |
| | Daveleen McHenry |
| | Steve McKenney |
| | Dean Morgan |
| | Katie Paul |
| | Brandon Rembe |
| | Francie Ringold |
| | Jane Ruberry |
| | Heidi and Timothy Sadler |
| | Dedra "Dede" Schendzielos |
| | Krysta Svore |
| | Scott Taffera |
| | Julia Walker |
| | David Zapolsky |

## COMMUNITY THANKS

Laird Norton Tyee, *The Art of Discovery* book corporate sponsor

| | |
|---|---|
| Francine Seders Gallery | Kathi Effenberger, Balanced Books Pro |
| Friesen Gallery | Patricia Rovzar Gallery |
| Greg Kucera Gallery | The Fountainhead Gallery |
| Grover / Thurston Gallery | Trophy Cupcakes |
| Halinka Wodzicki | Woodside / Braseth Gallery |
| Kate Gregory and Susan Thornberg | Wright Exhibition Space |

## THANK YOU TO THE FOLLOWING EDUCATORS AND SCHOOLS FOR THEIR ASSISTANCE

*Clyde Hill Elementary*
Lisa Aronovitz
April Hale
Jessica Holloway
Liisa Wihman

*Greenlake Elementary*
Dina Wilson

*Lake Forest Park Elementary*
Sharon Brooksbank
Alicia Buck
Kim Cleary
Janice Coe
Maureen Creagan
Chrisy Francescutti
Therese Frare
Randy Gangnes
Bambi Harvey
Susie Heushcer
Ali Keenan Howlett
Laurie King
Tim Nelson
Laurie Pearson
Sharon Ridge
Suzanne Rosenthal
Mary Beth Scherf
Ann Tuberg
Merrilyn Tucker

*Lakeview Elementary*
Beth Day

*The Little School*
Guy Fineout
Steve Goldenberg
Jessica Johnson
Joyce Kidd-Miller
Michael Murphy
Jenny Steen
Reko Sullivan
Sally Vongsathorn
Juli Wang

*Martha Lake Elementary*
Nancy Webster

*Rockwell Elementary*
Jessica Hargin